D1540991

THE FOOLPROOF METHOD

How to Draw an OBJECT

THE FOOLPROOF

METHOD

How to Draw
an
OBJECT

— Soizic Mouton —

ST. MARTIN'S GRIFFIN
NEW YORK

To my mom,
who taught me to watch,
and to take note

CONTENTS

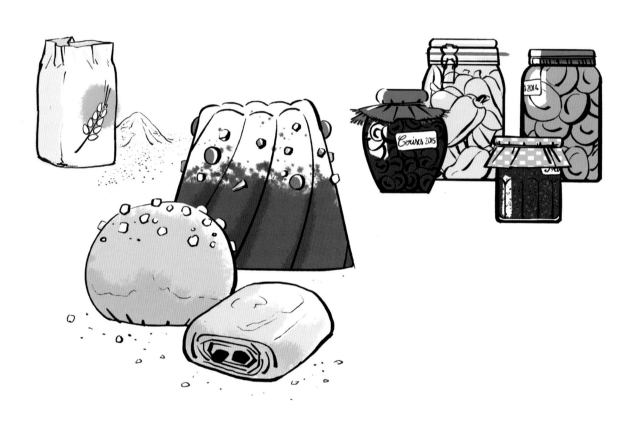

PREFACE

Whatever you want to draw, you need to get acquainted—just a bit— with perspective. For many of us, "perspective" is a scary word that calls to mind plastic rulers, vanishing points, erasers, and a big headache. But don't stress out! Learning just a few basic rules will be enough for you to give realistic shape to pretty much anything. And the most important rule is that rules are there to be broken. Sometimes it's better to totally ignore perspective just to make your drawing even more obvious. The aim here is to give you the keys to a drawing style that is quick to do, and engaging to look at. So get inspired by the examples, take a deep breath, and . . . get out there and draw it!

Get ready to say good-bye to those unidentified drawing objects!

Soizic Mouton

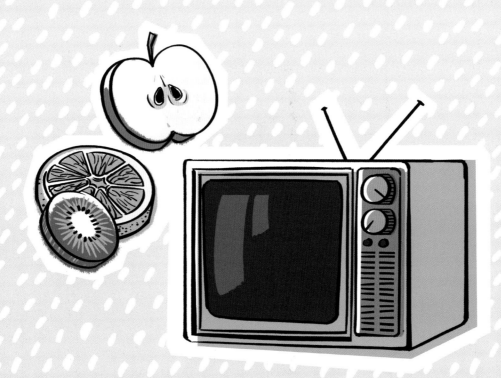

ANGLES
and
CURVES

PERSPECTIVE? Help!

Everything in the world is subject to the laws of perspective. Even if that sounds both tedious and slightly scary, we have to go with it if we are going to try to draw objects. But we will also discover how perspective can help us understand how objects look. And that we can actually cheat with perspective, too—so we're not getting superfrustrated instead of having fun. And let's start with some good news: It's the same technique for both rectangles and for circles. . . .

First, let's think about this mathematical rule:
Perspective = location within a space + viewpoint + vanishing point + horizon line.

The vanishing point is an imaginary point representing the infinite distance, which we place on the horizon line of the drawing. The horizon line marks the separation between the ground and the sky. And we need a vanishing point because all the parallel lines in a drawing will converge toward this exact point.

To start a drawing, we first need to decide where to place the horizon line and the vanishing point. Just by doing this, we are already making some big decisions about the drawing. There are an infinite number of vanishing points along the horizon line, and by taking just one step to one side or the other will already change the viewpoint, which will in turn change the vanishing point, and the perspective. The key is to figure out how to choose a good vanishing point, and a good horizon line.

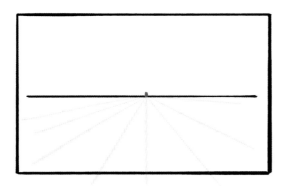

With the horizon line midway down the sheet of paper, and the vanishing point midway along the horizon line, you get a head-on viewpoint. This is one to avoid. The perspective won't be any easier to construct, and the drawing will risk looking a bit dull.

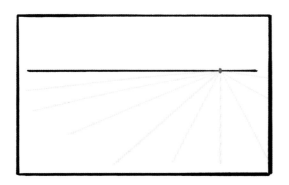

Putting the horizon line higher up on the paper can give the impression that we, the viewer, are either nearer to the ground, or small in relation to the overall scene, or even that the background is quite close to our viewpoint (like the wall of a room).

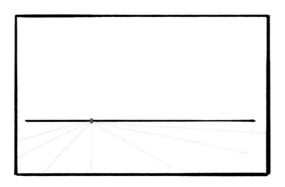

On the other hand, if the horizon line is lower down, it could show that we are very high up, or relatively tall, or that the backdrop is a long way off.

A LOOK AT BASIC PERSPECTIVE: EXAMPLE No. 1

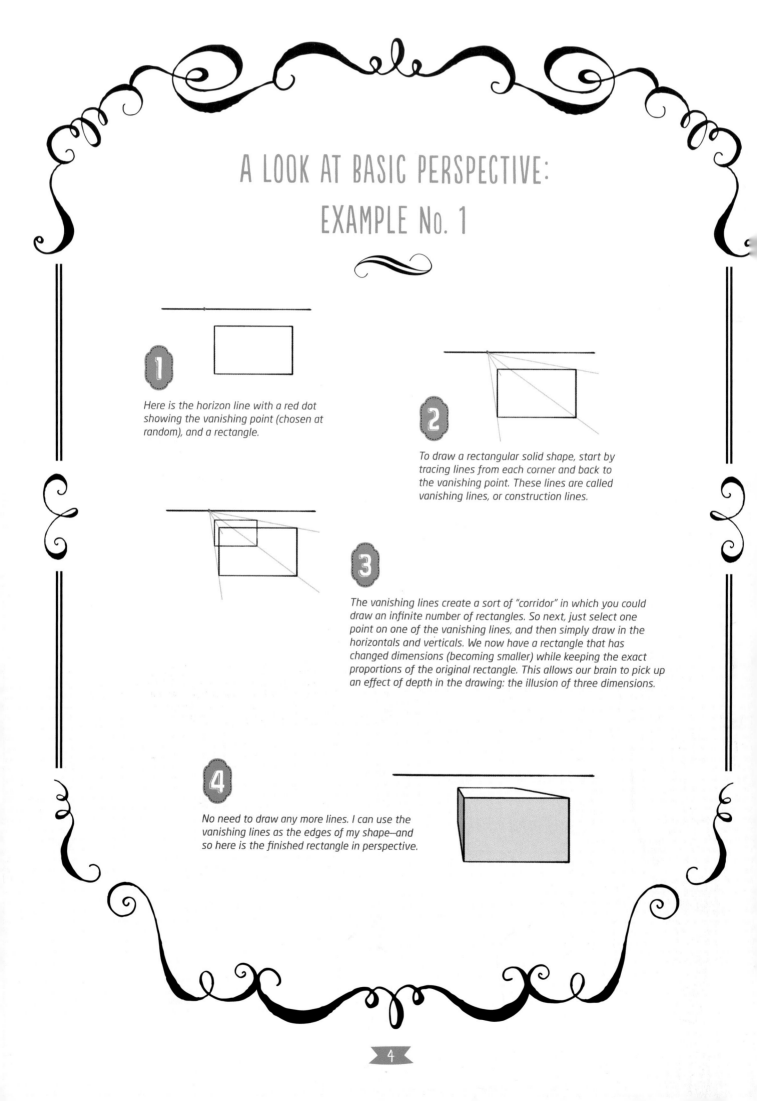

1

Here is the horizon line with a red dot showing the vanishing point (chosen at random), and a rectangle.

2

To draw a rectangular solid shape, start by tracing lines from each corner and back to the vanishing point. These lines are called vanishing lines, or construction lines.

3

The vanishing lines create a sort of "corridor" in which you could draw an infinite number of rectangles. So next, just select one point on one of the vanishing lines, and then simply draw in the horizontals and verticals. We now have a rectangle that has changed dimensions (becoming smaller) while keeping the exact proportions of the original rectangle. This allows our brain to pick up an effect of depth in the drawing: the illusion of three dimensions.

4

No need to draw any more lines. I can use the vanishing lines as the edges of my shape—and so here is the finished rectangle in perspective.

A LOOK AT BASIC PERSPECTIVE:
EXAMPLE No. 2

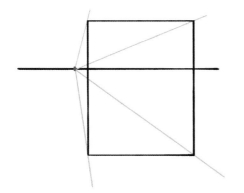

1

One thing to watch: in the previous example, we placed our rectangle completely below the horizon line. But we can just as easily place it across this line, or completely above it—and still be able to draw in the construction lines to the vanishing point.

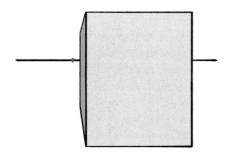

2

In the first example, we were looking down onto the object from above, and could see the top of it. This time, we are slightly below it, with the object placed on the ground and extending up into the sky section of the drawing. So we can no longer see the top of it.

A LOOK AT BASIC PERSPECTIVE: EXAMPLE No. 3

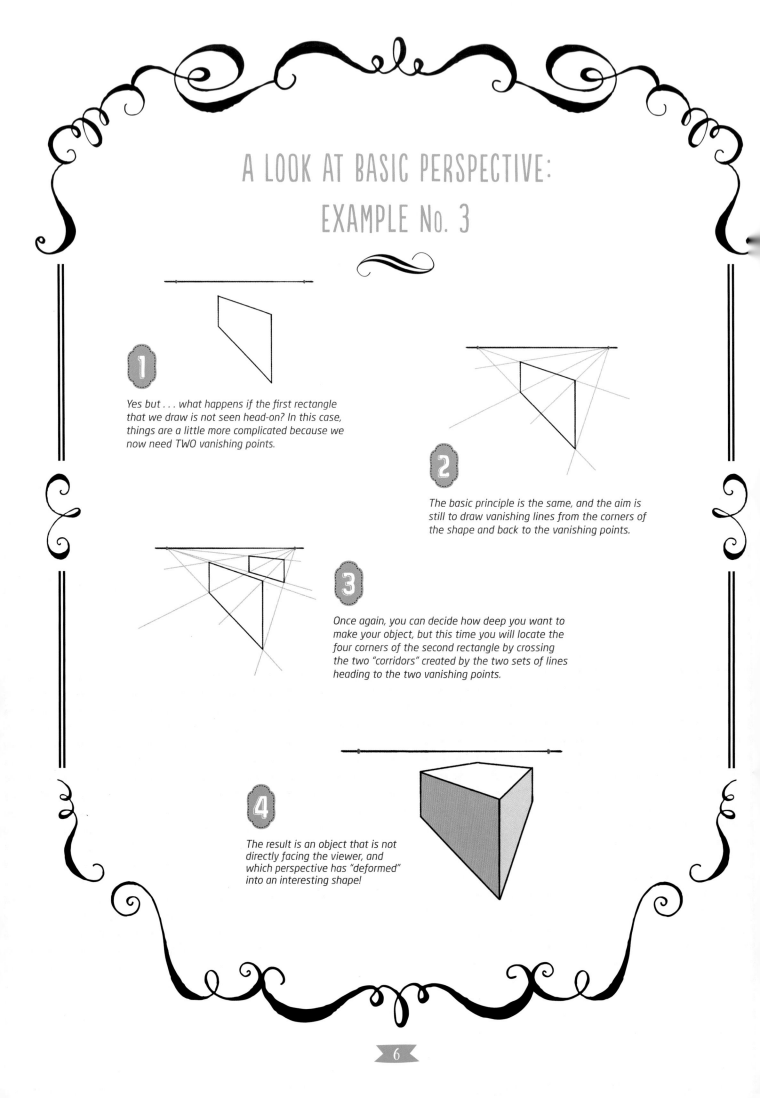

1

Yes but . . . what happens if the first rectangle that we draw is not seen head-on? In this case, things are a little more complicated because we now need TWO vanishing points.

2

The basic principle is the same, and the aim is still to draw vanishing lines from the corners of the shape and back to the vanishing points.

3

Once again, you can decide how deep you want to make your object, but this time you will locate the four corners of the second rectangle by crossing the two "corridors" created by the two sets of lines heading to the two vanishing points.

4

The result is an object that is not directly facing the viewer, and which perspective has "deformed" into an interesting shape!

A CIRCLE IN PERSPECTIVE

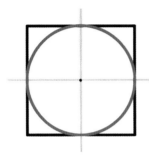

1

So how about a circle? It has no straight
edges or corners, so how do we put it in
perspective? Well, to start with, remember
that a circle can also be drawn inside a
square. . . .

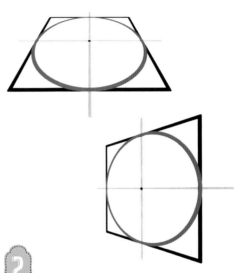

2

Once you do that, the circle simply follows the
same transformations that the square shape goes
through when drawn in perspective—so it basically
becomes more of an elliptical shape.

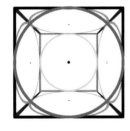

3

If you put the circle into a square, you can
always figure out how circles are going to look
in perspective—even with two vanishing points.
And these circles-in-boxes combinations look
pretty good, too.

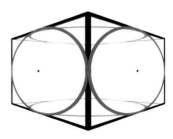

FROM CIRCLE TO CYLINDER

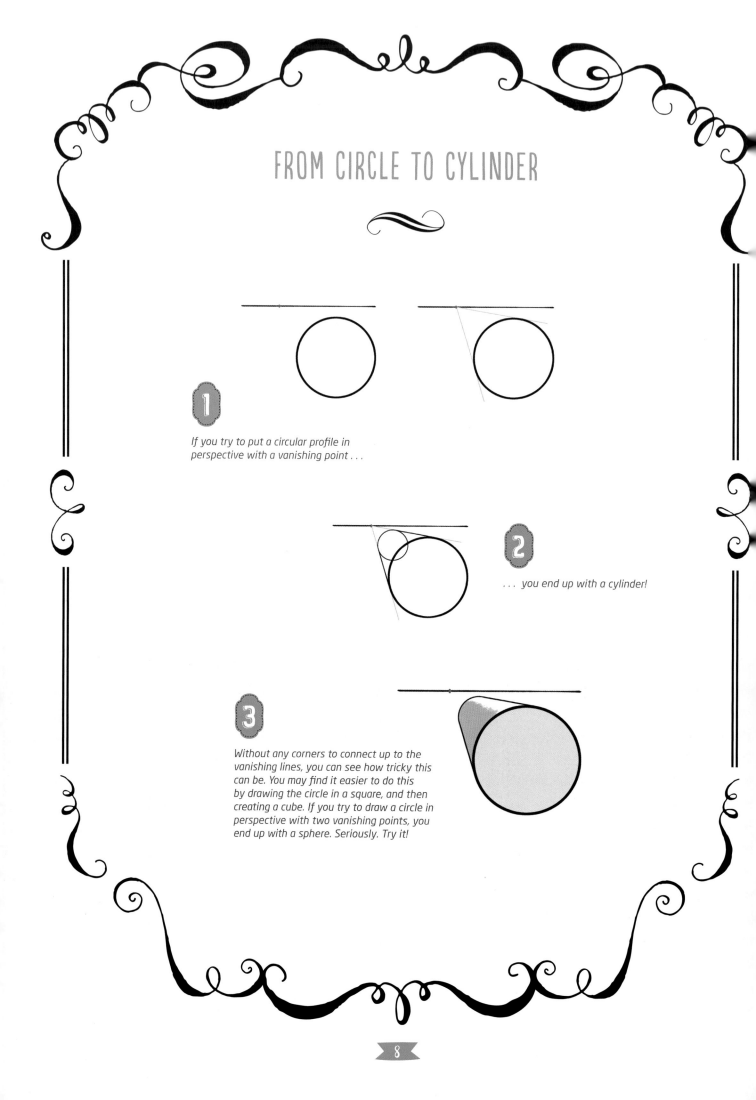

1 If you try to put a circular profile in perspective with a vanishing point . . .

2 . . . you end up with a cylinder!

3 Without any corners to connect up to the vanishing lines, you can see how tricky this can be. You may find it easier to do this by drawing the circle in a square, and then creating a cube. If you try to draw a circle in perspective with two vanishing points, you end up with a sphere. Seriously. Try it!

MORE ABOUT CYLINDERS

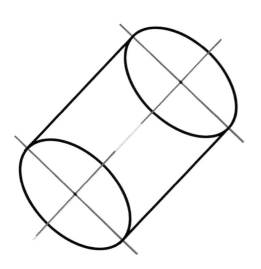

1

Right through the center there is an axis that also runs through the center of all the circles that make up the cylinder.

2

All the curves that run around the cylinder are parallel with each other.

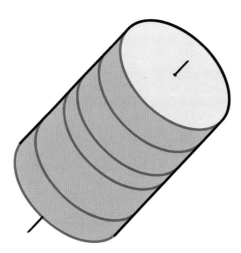

Those ELLIPSES: They're everywhere . . .

A TELESCOPE OF ELLIPSES

1

A telescope is made up of lots of ellipses that fit inside each other, so it's complicated to draw. . . .

However, we're going to cheat and try to do it as easily as possible. We start by drawing the glass lens at the front, with one side more curved out than the other.

2

Then, lightly draw a guideline axis through the middle of the lens, and then complete the first section of the telescope.

3

In the same way, draw in the other segments of the telescope, making sure the straight edges of each segment follow the same direction as your guideline axis, and that the curved lines are all roughly parallel.

4

Add a few extra details and . . .
Pirates on the horizon, Cap'n!

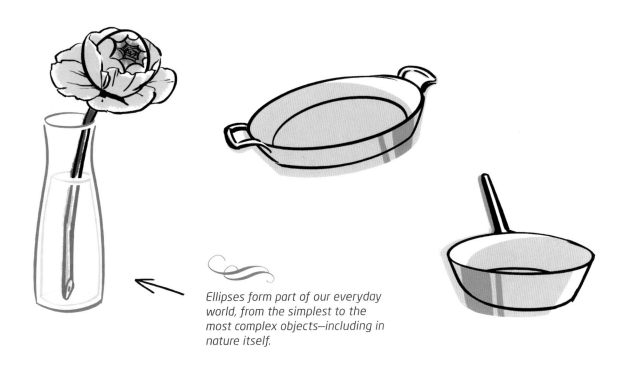

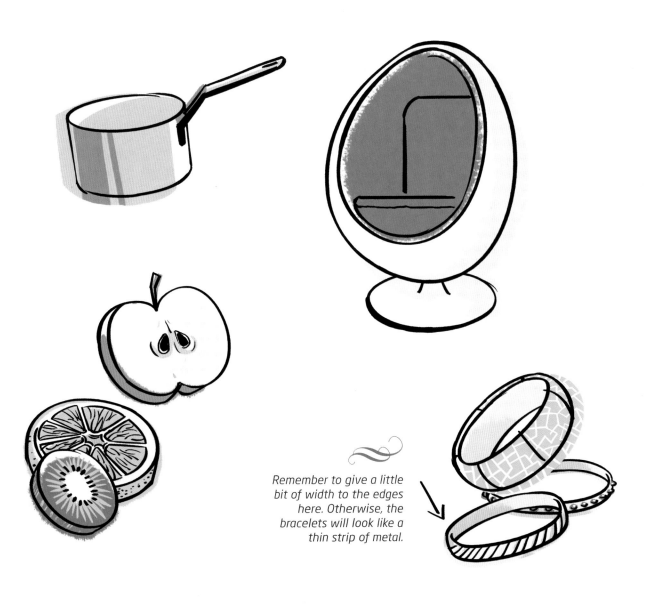

Ellipses form part of our everyday world, from the simplest to the most complex objects—including in nature itself.

Remember to give a little bit of width to the edges here. Otherwise, the bracelets will look like a thin strip of metal.

Messing with CUBES

~ A BIG OLD BOOK ~

1

Geometrically speaking, a book is actually a thing called a parallelepiped. Which basically means it's a 3D shape made up of parallelograms, which also means the key to drawing the book is to be able to draw parallel lines. Let's start with the two long sides of the front cover.

2

Join the corners to complete the cover, and then draw some guidelines to help create the thickness of the book. Little notches on these lines will help you to draw in the pages later.

3

Now draw in the visible edges of the back cover, which are parallel to the edges of the front cover, remembering to add a bit of thickness to show this is a hardcover book. I have drawn the spine of the book a bit rounded, but you could do it straight instead. You decide how thick to make the book—just follow those guidelines you drew in earlier on.

EDGAR ALLAN POE

4

A few extra details, and we have what looks like a good read!

Today's technology is giving us objects that are more and more compact and thin. But look carefully, and you will see the parallelograms arranged in various different ways.

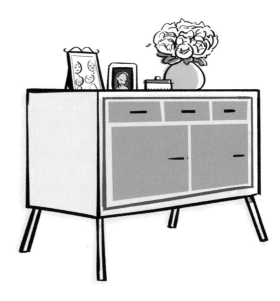

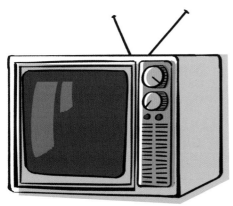

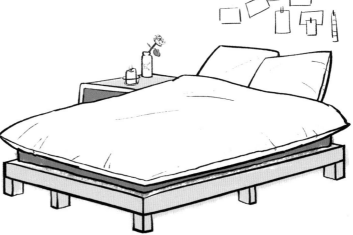

For all you millennials out there, this is not a microwave. It's a TV from the 1950s.

ANGLES + CURVES = infinite possibilities

After the circles and those parallelograms, the triangle is another geometric shape that we often come across. When combined with a square, a 3D triangle becomes a pyramid. When combined with a circle, it becomes a cone—which is what we're going to look at now.

THREE WAYS TO SEE A CONE

1 *From a profile view, a cone is an isosceles triangle, with the point of the cone connected to the center of the base by a straight line that is perpendicular to the base.*

2 *Adding a bit of perspective, we can now see that the base is actually a circle, and the axis from top-to-bottom intersects at the center of this circle and is perpendicular to its surface.*

3 *Seen from directly above—or directly below—the cone is simply a circle. The axis that runs through it remains at its center.*

INSIDE THE CONE

1 *The circle at the base of the cone gets repeated an infinite number of times in a series of ever-decreasing circles. Viewed from the tip of the cone to the base, it's a bit like a waveform—which is exactly what is represented by the familiar Wi-Fi logo!*

2 *You can also get a spiral inside a cone, which makes us think of seashells—or snails! The pleasing proportions of a seashell are in fact all based on math, and specifically the proportions of the "golden ratio" that can be found in lots of natural spiral phenomena—including the seeds on the head of a sunflower, or the scales of a pinecone.*

But enough math already! If you want a shortcut, draw an ellipse (a proper rounded one, or a pointy almond-shaped one like this) and then draw in the rest, just trying to keep it roughly symmetrical.

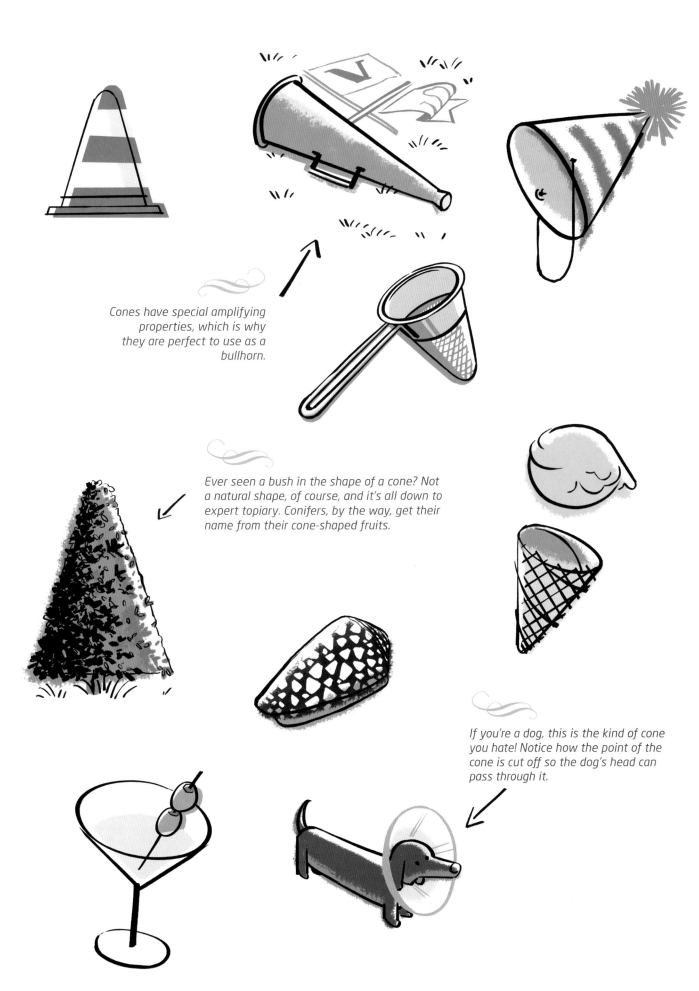

Cones have special amplifying properties, which is why they are perfect to use as a bullhorn.

Ever seen a bush in the shape of a cone? Not a natural shape, of course, and it's all down to expert topiary. Conifers, by the way, get their name from their cone-shaped fruits.

If you're a dog, this is the kind of cone you hate! Notice how the point of the cone is cut off so the dog's head can pass through it.

It's all SOFT!

There's a whole load of things, both natural and not, which have nothing to do with circles, or cubes, or anything at all really: things without a fixed shape, or with no shape at all. Let's look at how we might approach drawing this kind of stuff.

Wind has no shape or form. And if the wind is not blowing, we can't draw it. All we can do is to try to draw its movement, or the movement it gives to other objects.

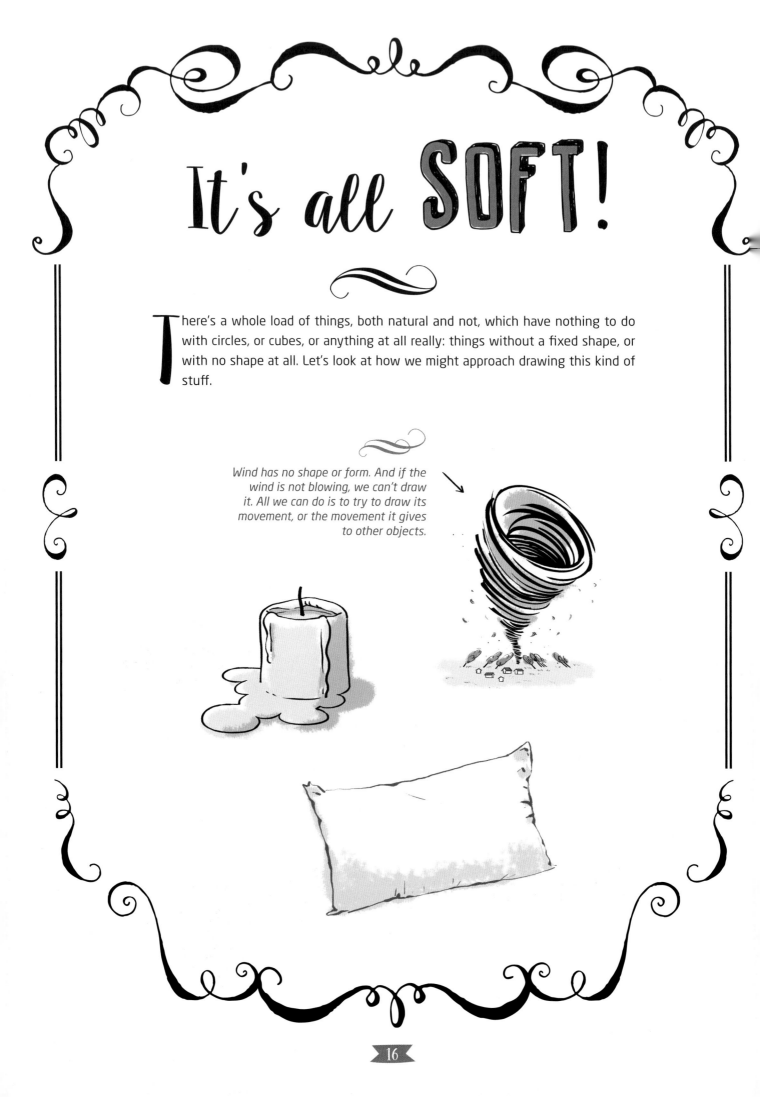

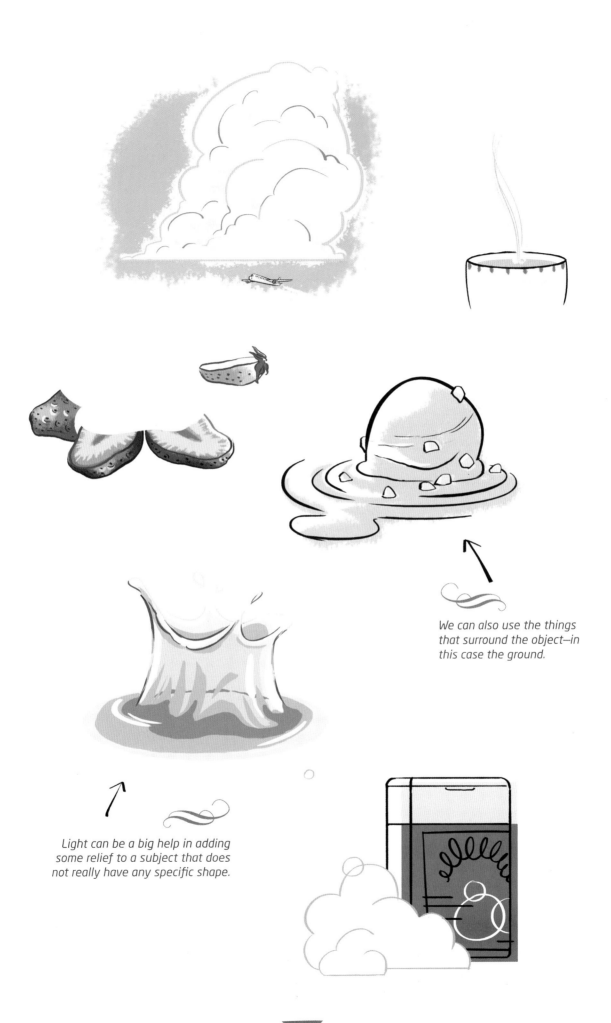

We can also use the things that surround the object—in this case the ground.

Light can be a big help in adding some relief to a subject that does not really have any specific shape.

TEXTILE Style

When it comes to drawing fabric, there's not much theory to be learned. Apart from gravity, which makes fabric drape, or light, which adds shadow and highlights, there are no special rules to help us out. Textiles move pretty randomly, and the best way to learn is simply to observe!

~ TIME TO DRAW THE CURTAINS ~

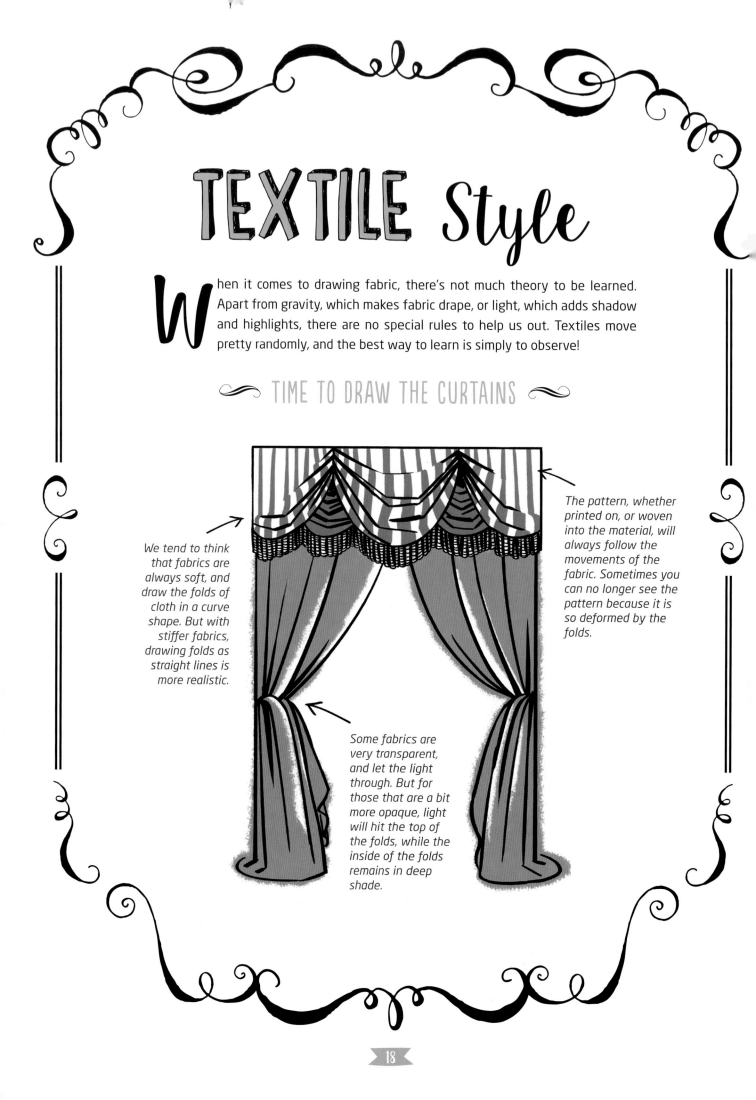

We tend to think that fabrics are always soft, and draw the folds of cloth in a curve shape. But with stiffer fabrics, drawing folds as straight lines is more realistic.

The pattern, whether printed on, or woven into the material, will always follow the movements of the fabric. Sometimes you can no longer see the pattern because it is so deformed by the folds.

Some fabrics are very transparent, and let the light through. But for those that are a bit more opaque, light will hit the top of the folds, while the inside of the folds remains in deep shade.

The thicker the fabric, the less you see the folds.

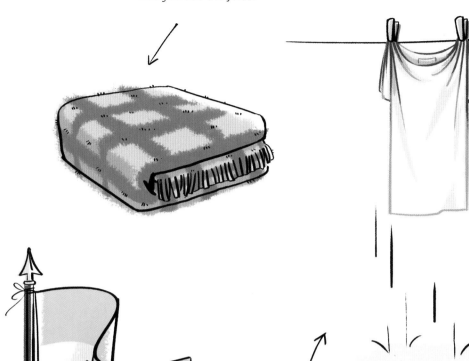

The way a fabric drapes says a lot about what kind of textile it is made of. Not all fabrics have the same weight: the heaviest drape straight down, while the lightest ones will move with the slightest wind. Wet fabric is very heavy and is pulled down by the weight of water.

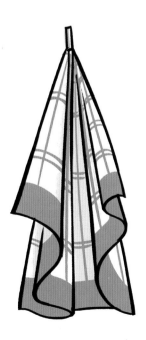

Normally, when you buy fitted sheets, you're not supposed to get creases. But on my bed, they always look a bit like this. . . .

The
WORLD
of
THINGS

In the KITCHEN

A COFFEE GRINDER

1

Start with three vertical straight lines, and join them up to create the box section of the coffee grinder.

2

Carry on by drawing the base of the grinder, following the lines you have just drawn. Then draw the top of the grinder box as a perfectly horizontal line with no perspective added.

3

Once the box is complete, make a very simple drawing of the grinder handle.

4

With a few extra details, the grinder is ready. Take a coffee break! Go on, you deserve it!

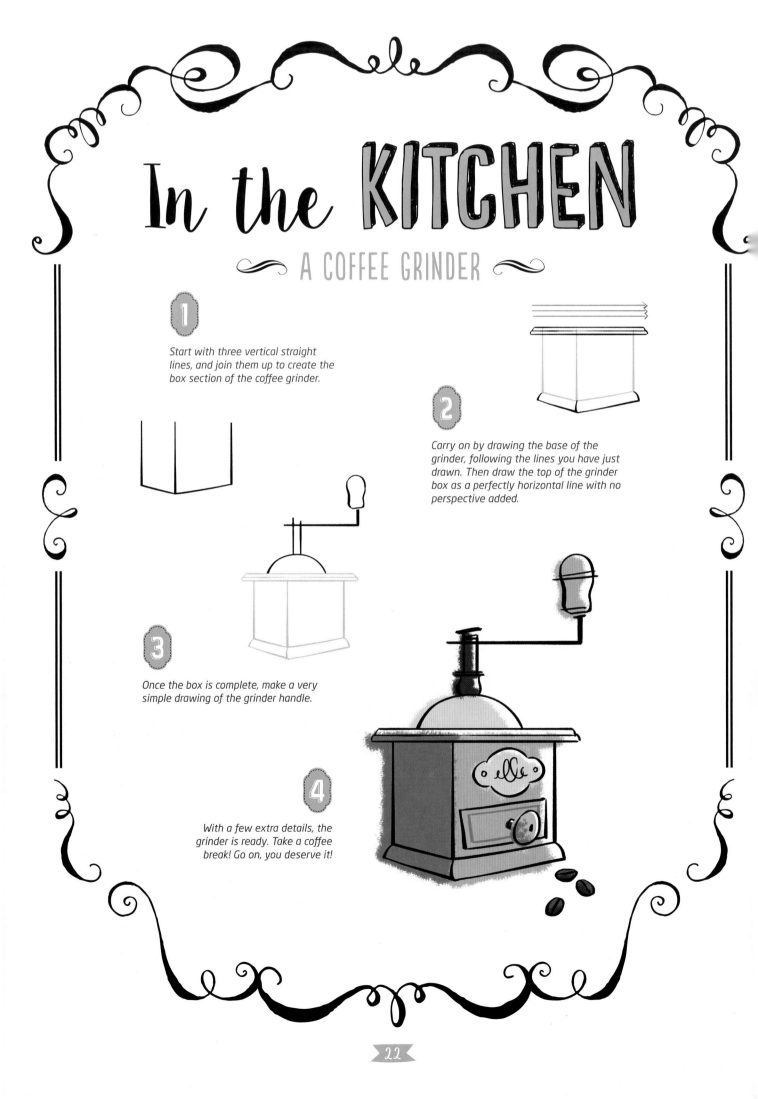

Just by adding a few reflections of light, you can give a strong impression of volume and depth—even with absolutely no other perspective effects!

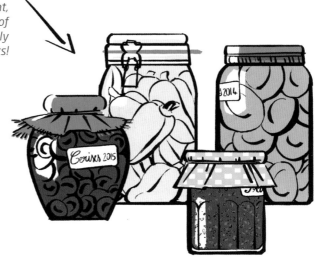

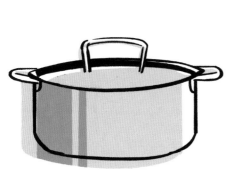

The more flour there is in the packet, the fewer folds and creases there are to draw.

DINNER'S Ready!

~ CANDLELIT DINNER FOR TWO ~

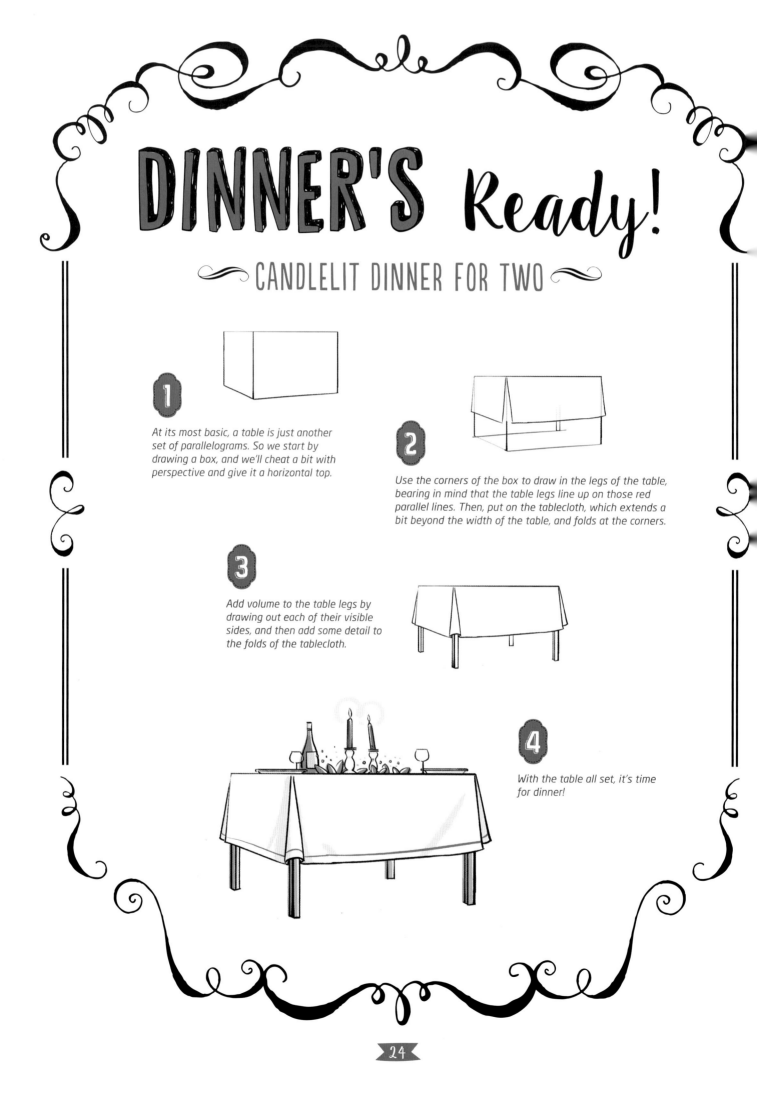

1

At its most basic, a table is just another set of parallelograms. So we start by drawing a box, and we'll cheat a bit with perspective and give it a horizontal top.

2

Use the corners of the box to draw in the legs of the table, bearing in mind that the table legs line up on those red parallel lines. Then, put on the tablecloth, which extends a bit beyond the width of the table, and folds at the corners.

3

Add volume to the table legs by drawing out each of their visible sides, and then add some detail to the folds of the tablecloth.

4

With the table all set, it's time for dinner!

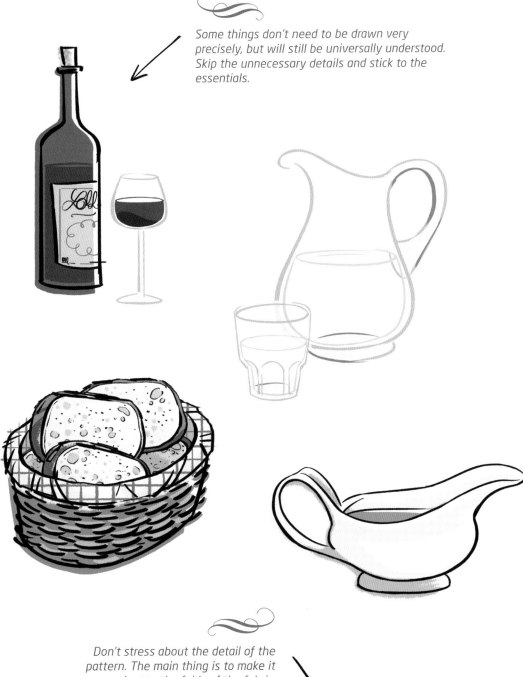

Some things don't need to be drawn very precisely, but will still be universally understood. Skip the unnecessary details and stick to the essentials.

Don't stress about the detail of the pattern. The main thing is to make it adapt to the folds of the fabric.

FOODIE Special

CELEBRATION CAKE

1 This tiered cake is basically a stack of cylinders that gets narrower as you go up. If you strictly followed the rules of perspective, you'd have to draw a whole load of ellipses, a pair for each tier, reducing the size each time. Too much hassle? Then, instead of drawing the base of the cake, start with a simple straight line. Then, draw an almond-shape for the cake top.

2 Connect the two elements, and you get the first tier, and then repeat the same process twice for the two smaller cake tiers. Make sure you center each tier, without overlapping the edges of the cake below, as this helps create the sense of perspective.

3 Add some cream and cherries, making sure the cream runs well past the edges of the cake. The more it gloops beyond the edges, the thicker it will look. For the cherries, it's great to draw in a few that are partly hidden by the other tiers of cake, as these will enhance the 3D feel of the drawing without any special perspective tricks.

4 So in just three easy stages—tadaa! A magnificent birthday cake to impress your guests. Especially if you're a terrible cook. . . .

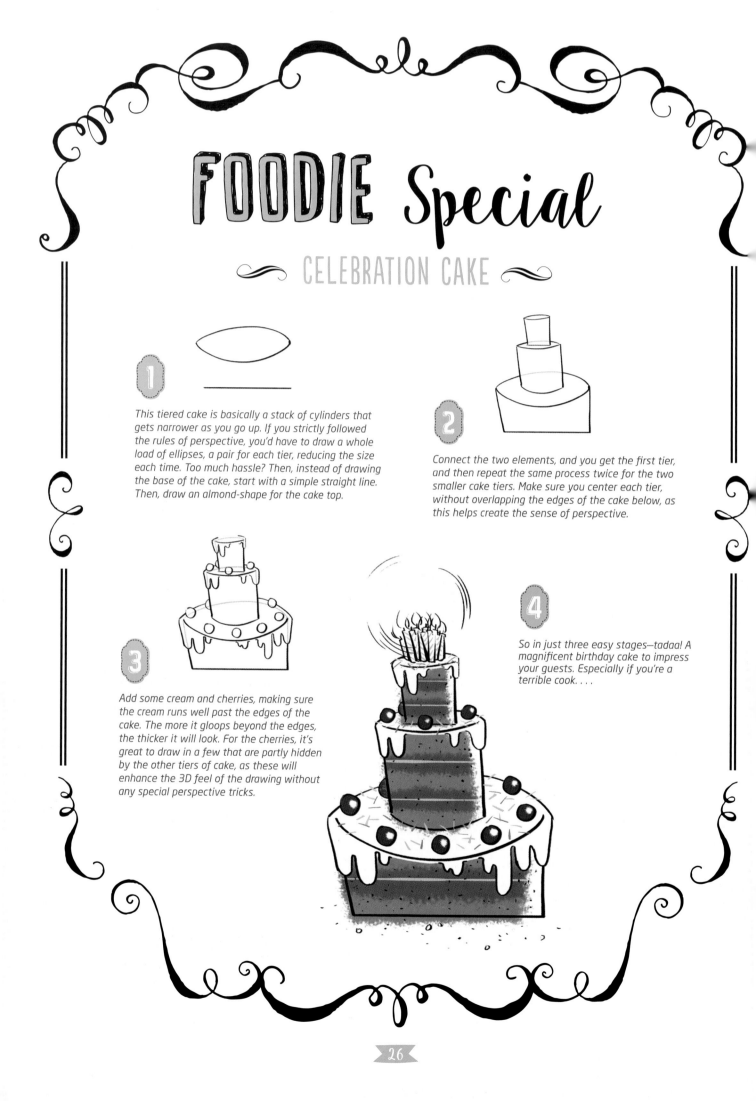

It's 4 p.m. already? Time to
draw a quick snack!

Stylish design and great food have
been perfect partners forever—and
are the most fun to draw!

In the BATHROOM

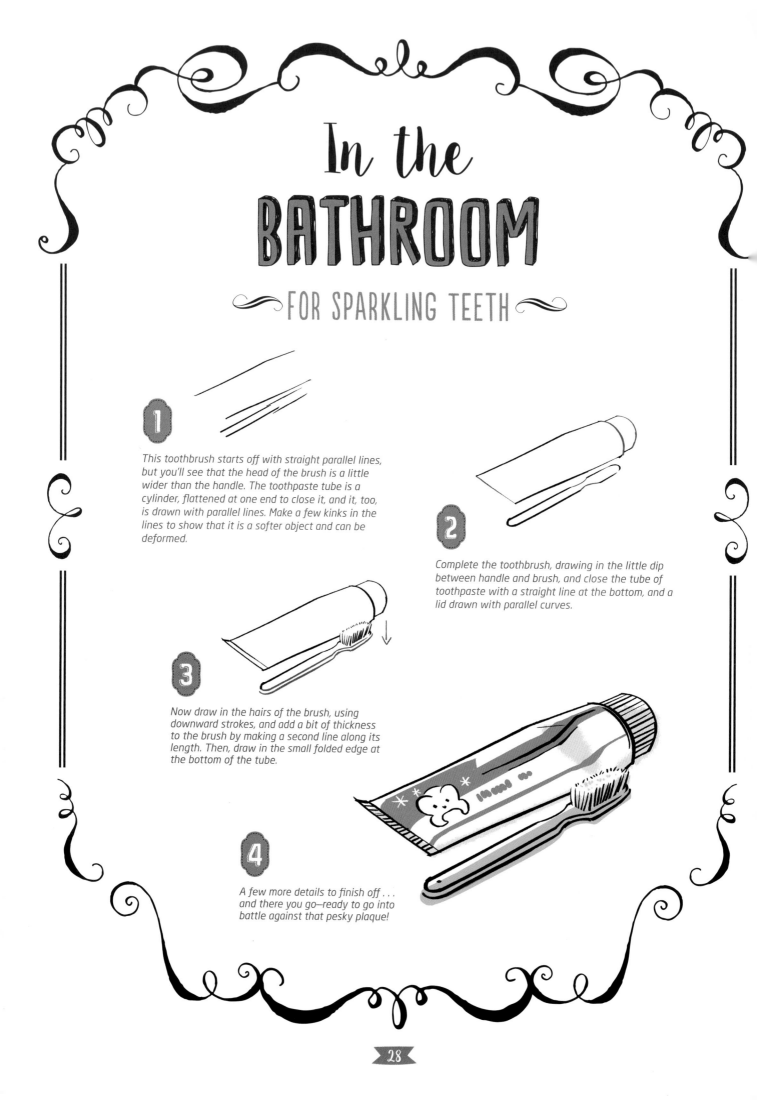

∽ FOR SPARKLING TEETH ∽

1

This toothbrush starts off with straight parallel lines, but you'll see that the head of the brush is a little wider than the handle. The toothpaste tube is a cylinder, flattened at one end to close it, and it, too, is drawn with parallel lines. Make a few kinks in the lines to show that it is a softer object and can be deformed.

2

Complete the toothbrush, drawing in the little dip between handle and brush, and close the tube of toothpaste with a straight line at the bottom, and a lid drawn with parallel curves.

3

Now draw in the hairs of the brush, using downward strokes, and add a bit of thickness to the brush by making a second line along its length. Then, draw in the small folded edge at the bottom of the tube.

4

A few more details to finish off . . . and there you go—ready to go into battle against that pesky plaque!

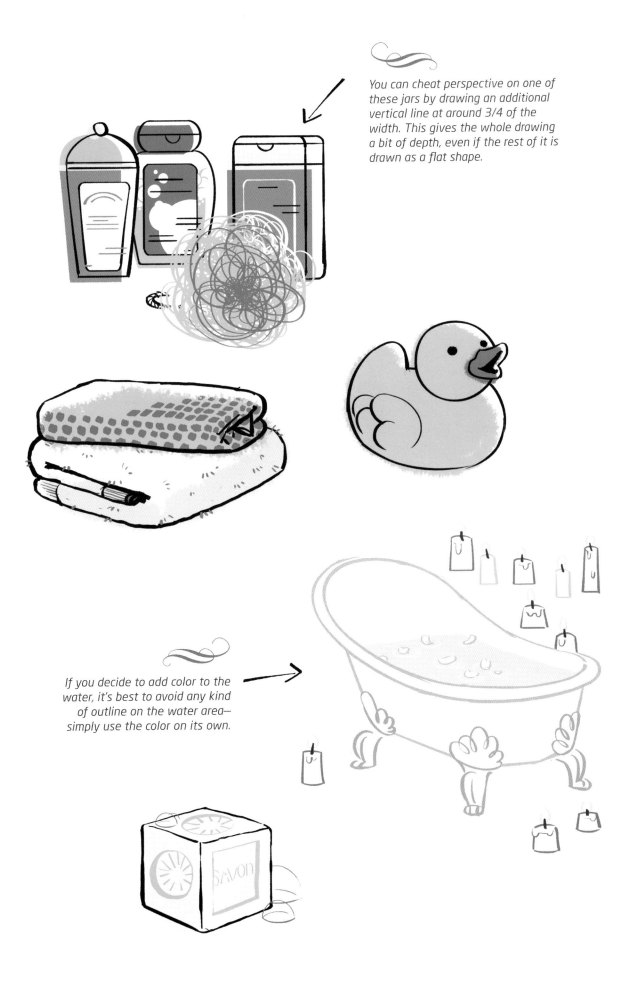

You can cheat perspective on one of these jars by drawing an additional vertical line at around 3/4 of the width. This gives the whole drawing a bit of depth, even if the rest of it is drawn as a flat shape.

If you decide to add color to the water, it's best to avoid any kind of outline on the water area— simply use the color on its own.

What to WEAR

~ PAPER CLOTHES ~

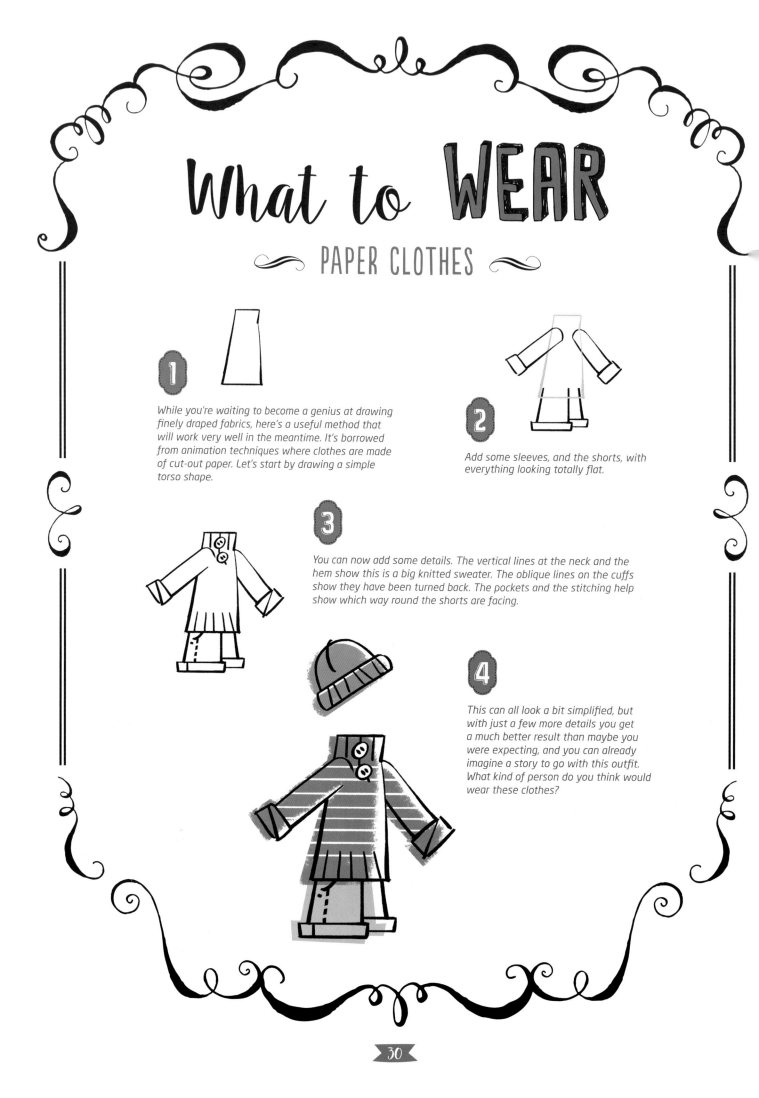

1 While you're waiting to become a genius at drawing finely draped fabrics, here's a useful method that will work very well in the meantime. It's borrowed from animation techniques where clothes are made of cut-out paper. Let's start by drawing a simple torso shape.

2 Add some sleeves, and the shorts, with everything looking totally flat.

3 You can now add some details. The vertical lines at the neck and the hem show this is a big knitted sweater. The oblique lines on the cuffs show they have been turned back. The pockets and the stitching help show which way round the shorts are facing.

4 This can all look a bit simplified, but with just a few more details you get a much better result than maybe you were expecting, and you can already imagine a story to go with this outfit. What kind of person do you think would wear these clothes?

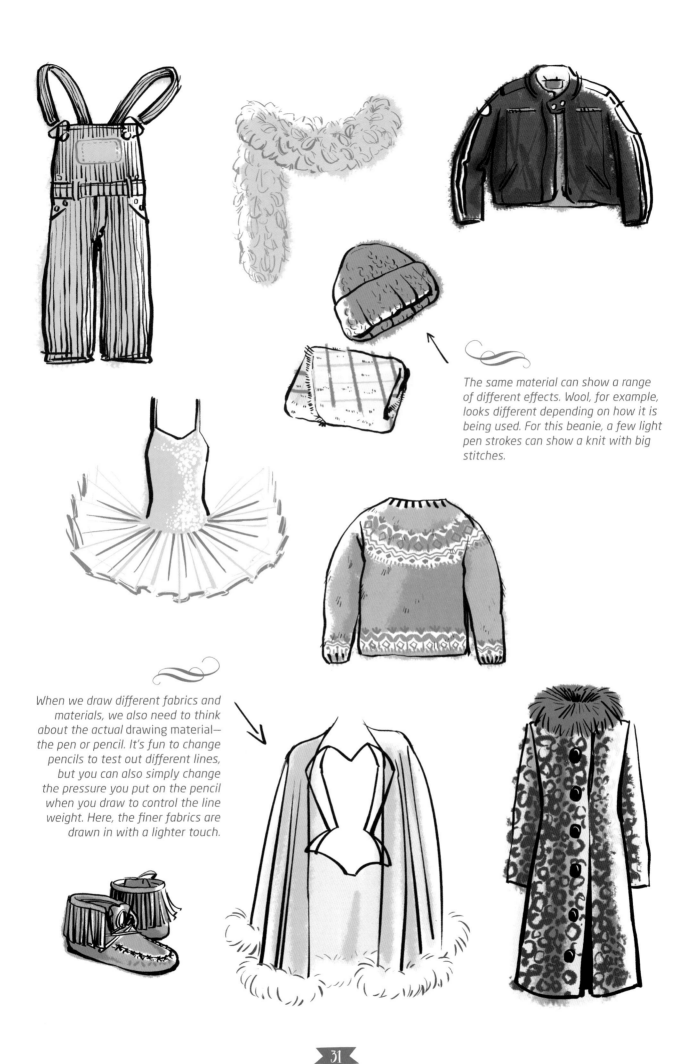

The same material can show a range of different effects. Wool, for example, looks different depending on how it is being used. For this beanie, a few light pen strokes can show a knit with big stitches.

When we draw different fabrics and materials, we also need to think about the actual drawing material—the pen or pencil. It's fun to change pencils to test out different lines, but you can also simply change the pressure you put on the pencil when you draw to control the line weight. Here, the finer fabrics are drawn in with a lighter touch.

Love My DIY!

~ A SCREWDRIVER ~

1

Let's start with the tip of the screwdriver. The construction of the whole drawing will be based on this point.

2

Next, we add the outline of the handle, following the arrow-like direction at the tip of the screwdriver. As we know already, all the parallel lines will converge at a vanishing point. And that's all you need to keep in mind here, no need for construction lines and fiddly techniques: just take all those lines to a single point.

3

We can finish the handle by adding some ellipses, parallel to each other, and perpendicular to the long axis that runs through the center of the screwdriver.

4

Add a quick bit of color and a couple of screws, and now you're all set to fix that squeaky cupboard door . . .

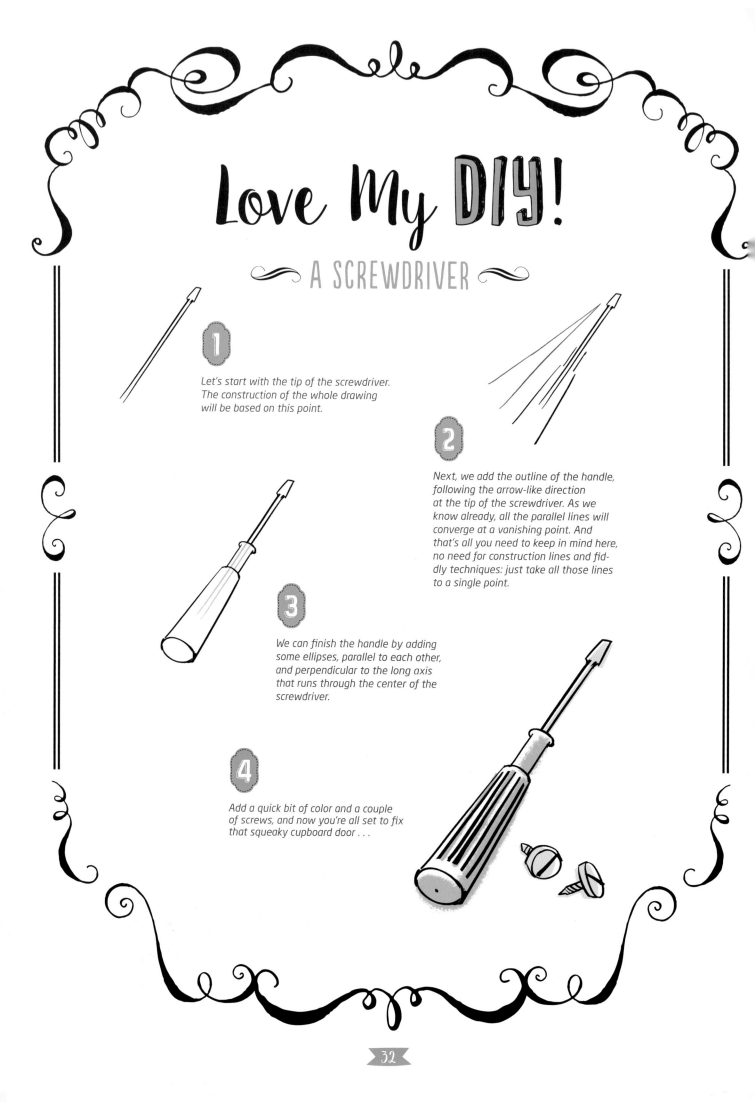

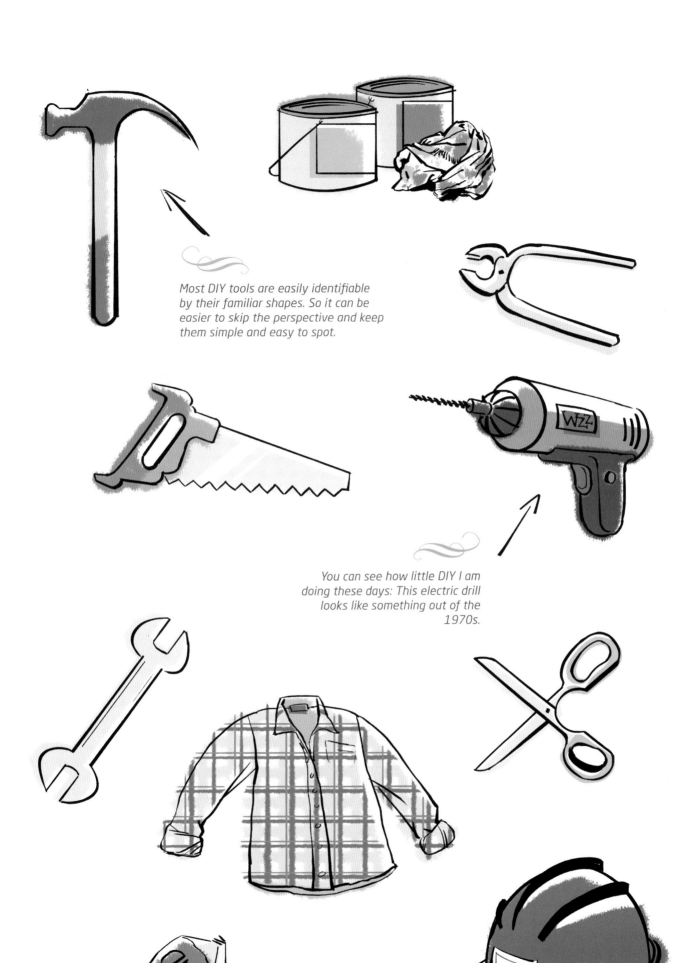

Most DIY tools are easily identifiable by their familiar shapes. So it can be easier to skip the perspective and keep them simple and easy to spot.

You can see how little DIY I am doing these days: This electric drill looks like something out of the 1970s.

Get to WORK!

A READING LAMP

1 Start with an ellipse for the base of the lamp. It needs to be nicely horizontal so the lamp sits level.

2 Let's forget about perspective and just concentrate on the silhouette of the lamp—drawing in the various elements as simply as possible.

3 Now add a few details to connect the different parts, and then add a bit of volume to the base, making sure you keep the curves as parallel as you can.

4 A few finishing touches later, and you can go switch on the light!

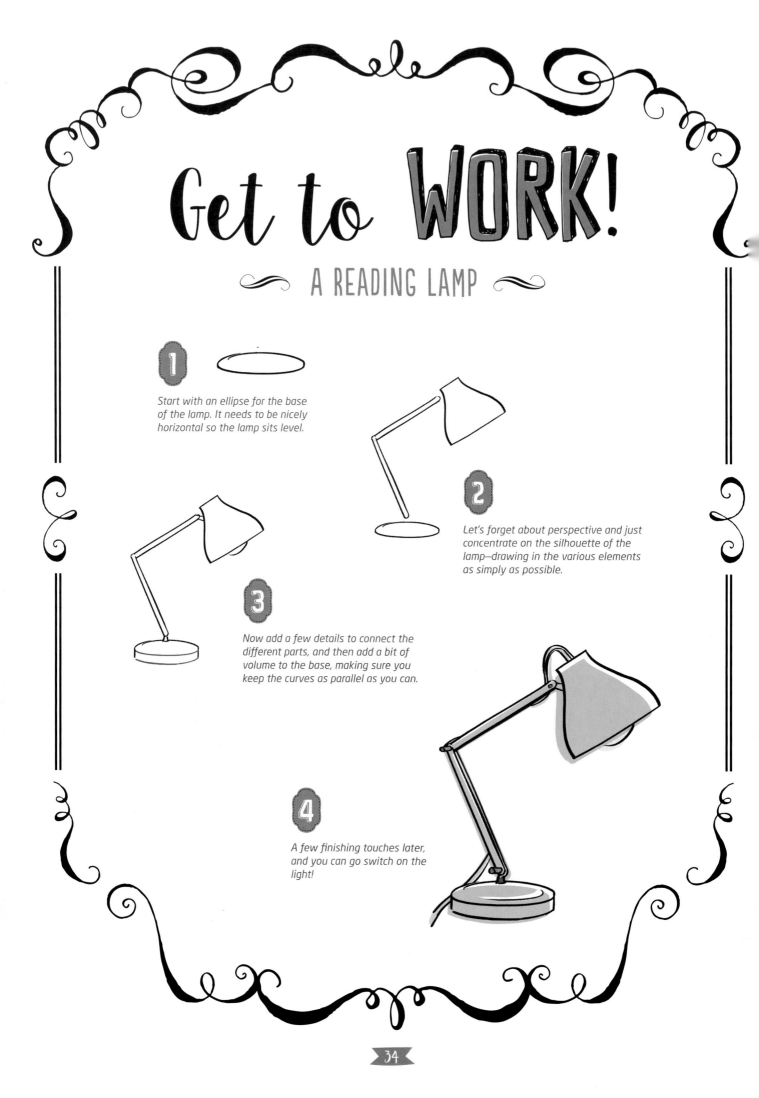

This is real cheating! From this viewpoint, we would not normally see the pages. But a book with pages is much easier to read!

Even when it's screwed up in a ball, a sheet of paper is still essentially made up of straight lines.

SPORT & Fitness

~ BADMINTON PARTY ~

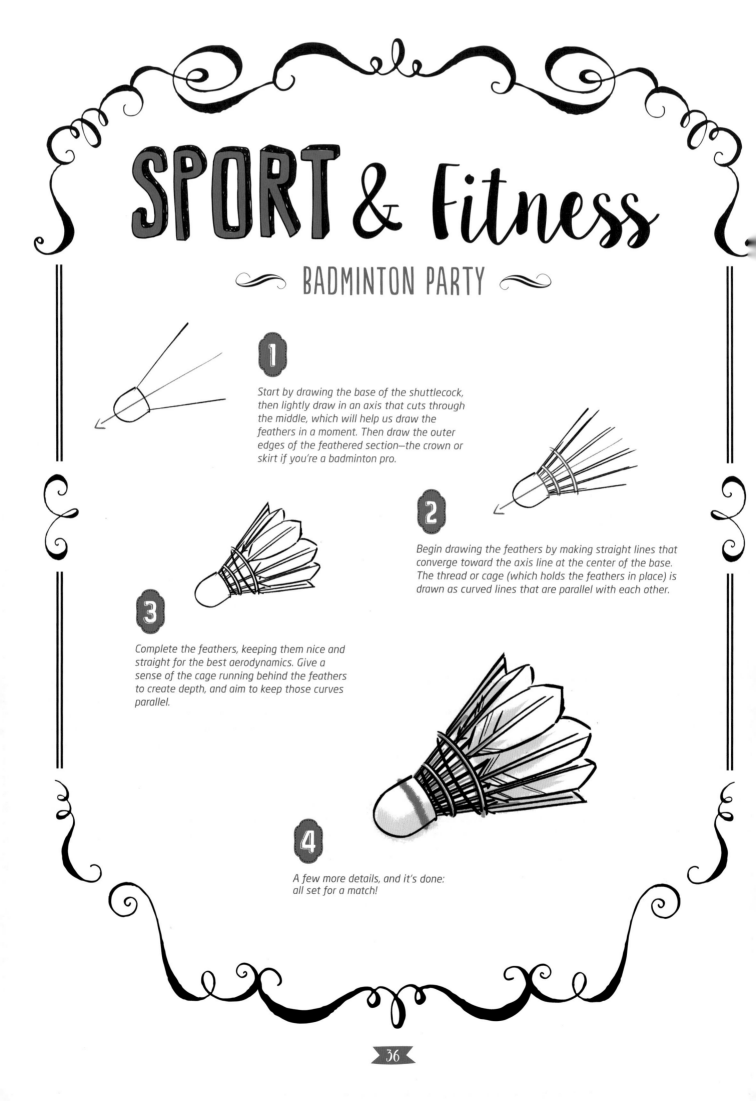

1

Start by drawing the base of the shuttlecock, then lightly draw in an axis that cuts through the middle, which will help us draw the feathers in a moment. Then draw the outer edges of the feathered section—the crown or skirt if you're a badminton pro.

2

Begin drawing the feathers by making straight lines that converge toward the axis line at the center of the base. The thread or cage (which holds the feathers in place) is drawn as curved lines that are parallel with each other.

3

Complete the feathers, keeping them nice and straight for the best aerodynamics. Give a sense of the cage running behind the feathers to create depth, and aim to keep those curves parallel.

4

A few more details, and it's done: all set for a match!

Uh-oh! Too many ellipses? No problem: you can cheat by using almond shapes instead.

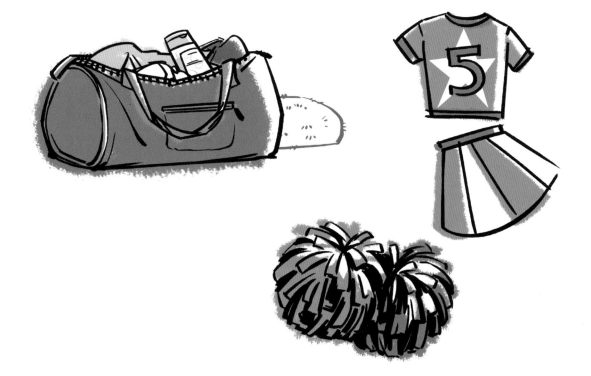

To keep this drawing easy to follow, don't color in the water but just draw in the surface contour.

The ART Studio

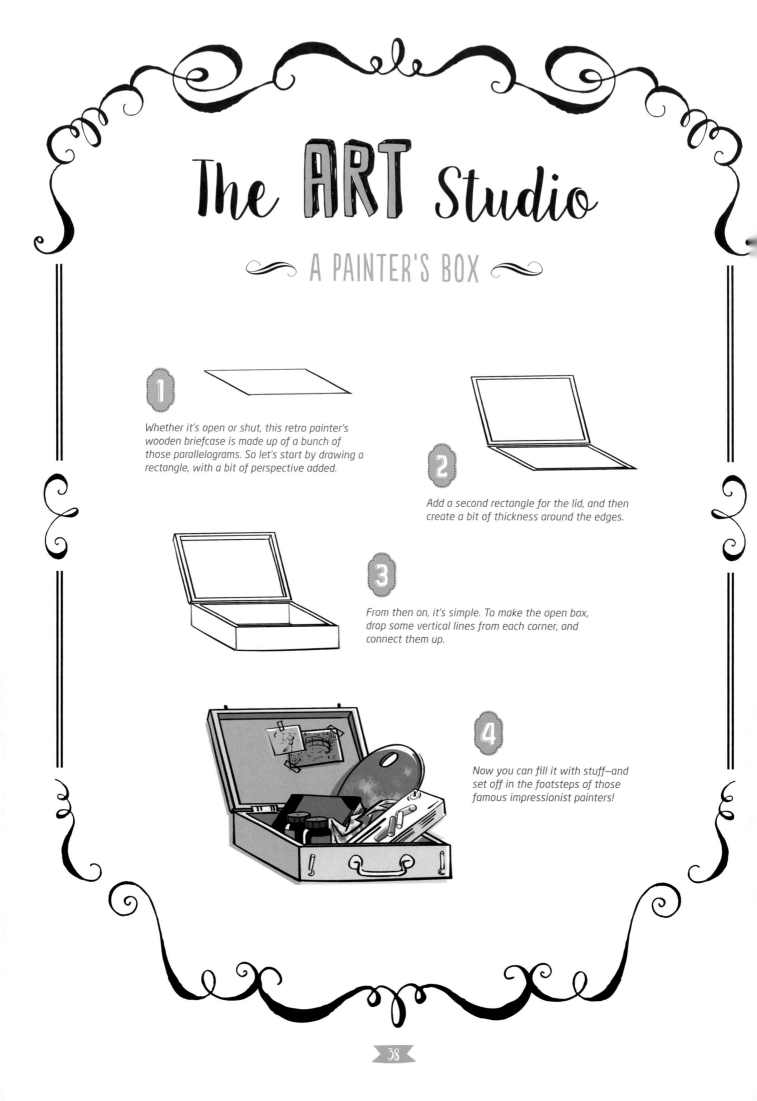

1

Whether it's open or shut, this retro painter's wooden briefcase is made up of a bunch of those parallelograms. So let's start by drawing a rectangle, with a bit of perspective added.

2

Add a second rectangle for the lid, and then create a bit of thickness around the edges.

3

From then on, it's simple. To make the open box, drop some vertical lines from each corner, and connect them up.

4

Now you can fill it with stuff—and set off in the footsteps of those famous impressionist painters!

Some objects are designed to be flat and straight. But the more they are used, the more deformed they can get.

Notice how folds in the fabric often start from the stitched seams in the clothing.

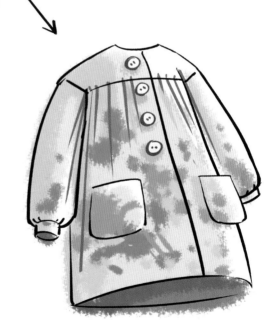

THRIFT SHOP Special

RETRO TELEPHONE

1 Start by lightly drawing the base of the telephone. It's a rectangle, but drawn in perspective, so not all the lines are parallel.

2 Next, you "build" the body of the telephone onto the base, making sure the back is much higher than the front.

3 Now place the handset of the phone on the body, and draw the dial as an ellipse, making it as big as possible while still fitting on the front.

4 Don't forget to draw in those finger holes on the dial, and the iconic spiral telephone cable. . . .

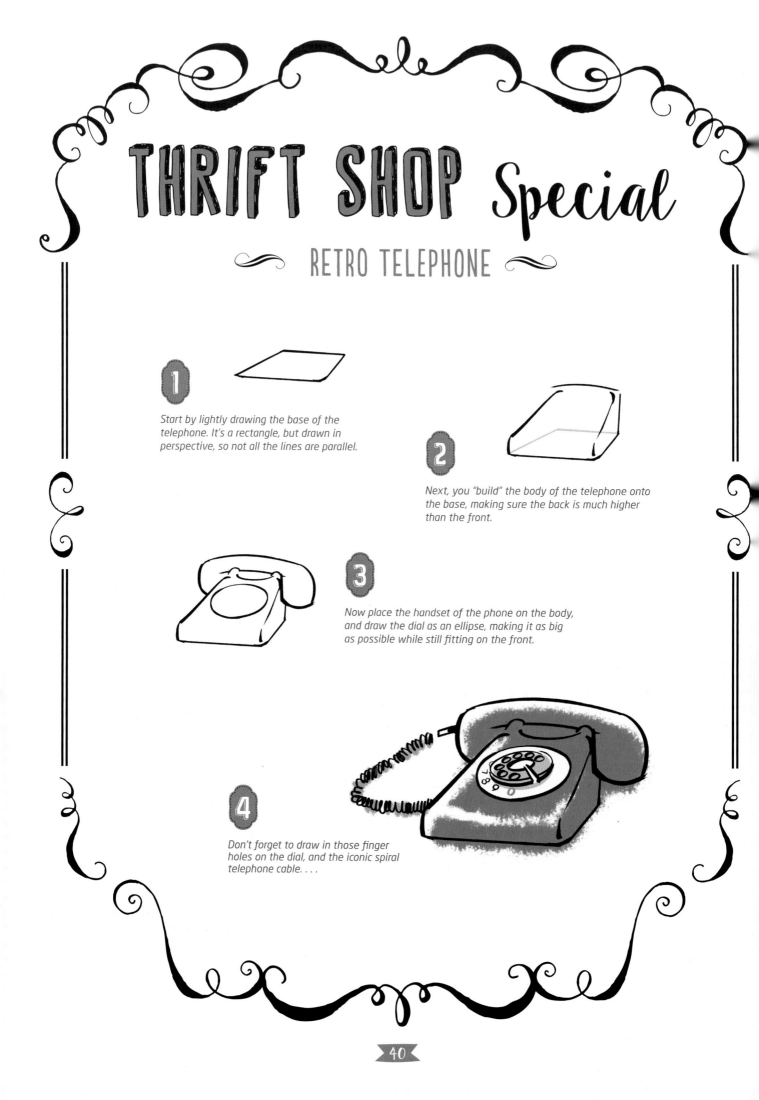

It is totally OK to mix up very stylized designs with more realistic stuff.

The simplest shapes are not always the easiest ones to draw!

On the ROAD

~ A DUMP TRUCK ~

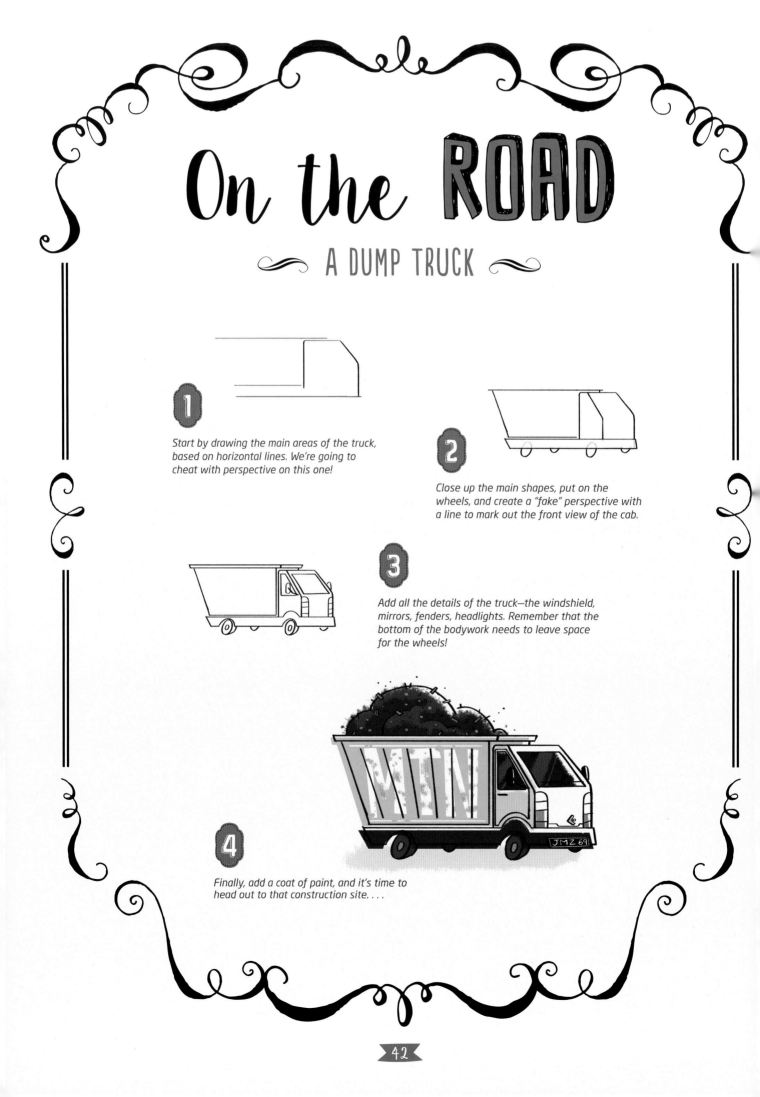

1 Start by drawing the main areas of the truck, based on horizontal lines. We're going to cheat with perspective on this one!

2 Close up the main shapes, put on the wheels, and create a "fake" perspective with a line to mark out the front view of the cab.

3 Add all the details of the truck—the windshield, mirrors, fenders, headlights. Remember that the bottom of the bodywork needs to leave space for the wheels!

4 Finally, add a coat of paint, and it's time to head out to that construction site. . . .

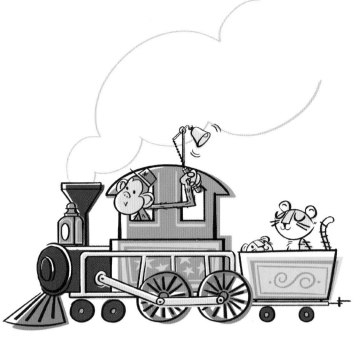

I know that nobody drives this kind of train, but it's got a lot more charm than your regular Amtrak, right?

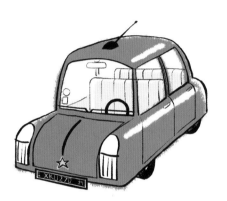

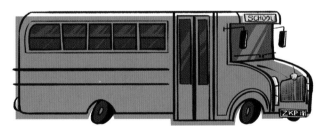

It's pretty difficult to draw a bike, even in side profile. So good luck trying to do it in perspective!

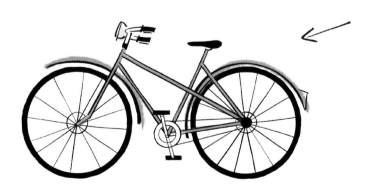

VACATION Time!

∼ BUCKETS ON THE BEACH ∼

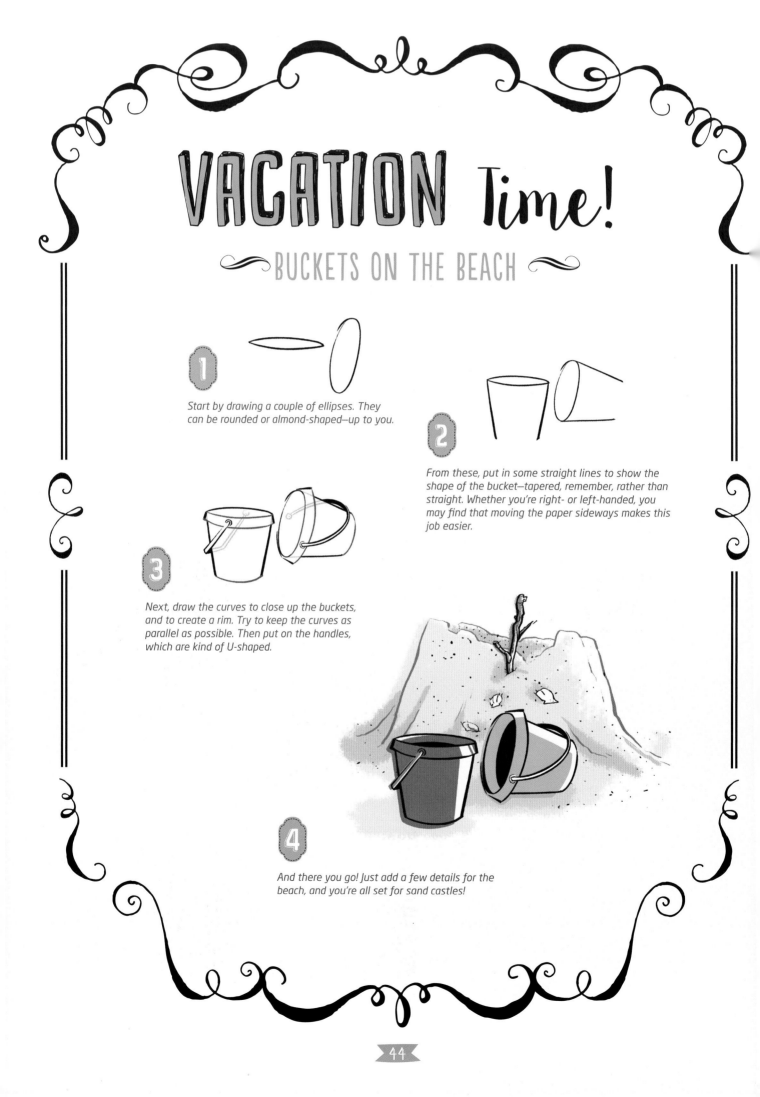

1 Start by drawing a couple of ellipses. They can be rounded or almond-shaped—up to you.

2 From these, put in some straight lines to show the shape of the bucket—tapered, remember, rather than straight. Whether you're right- or left-handed, you may find that moving the paper sideways makes this job easier.

3 Next, draw the curves to close up the buckets, and to create a rim. Try to keep the curves as parallel as possible. Then put on the handles, which are kind of U-shaped.

4 And there you go! Just add a few details for the beach, and you're all set for sand castles!

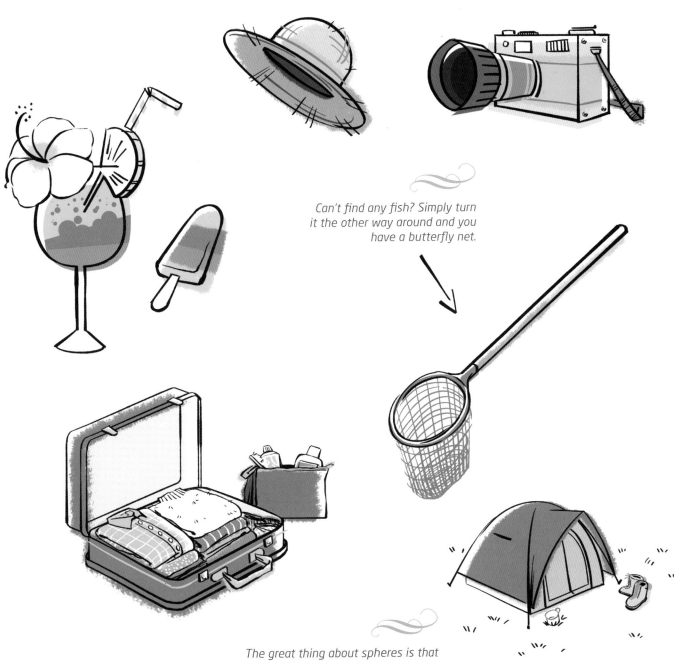

Can't find any fish? Simply turn it the other way around and you have a butterfly net.

The great thing about spheres is that they always remain perfectly round—from any angle or perspective! So it's just the pattern here that shows which way round the ball is facing.

Making MUSIC!

~ BOOM BOX ~

1 No surprises here—we're going to cheat with perspective again. Start with a horizontal line to show the bottom of the portable stereo.

2 Use vertical lines to show the dimensions and make rounded corners, just like on the real thing.

3 We're talking parallelograms again—complete the shape, and add a handle and the loudspeakers. Even when drawn this simply, you can already see what it is.

4 And now, with a few final details, your iconic boom box is complete.

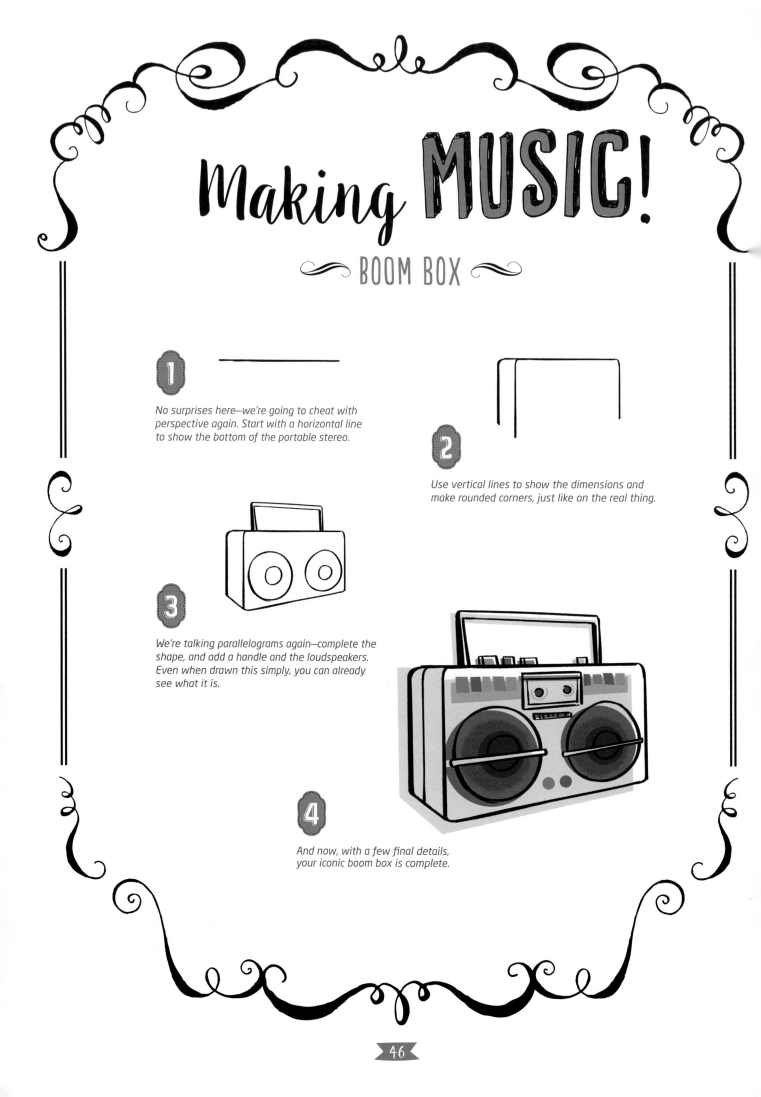

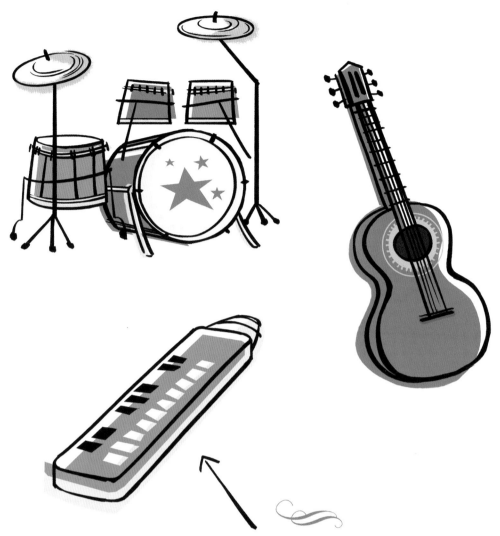

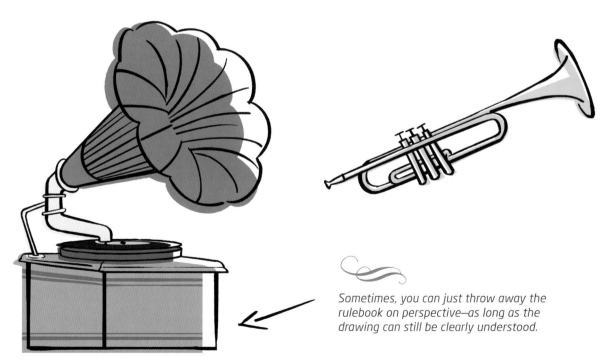

The melodica is one of those amazing inventions from the 1950s—you blow into the mouthpiece and play it like a piano!

Sometimes, you can just throw away the rulebook on perspective—as long as the drawing can still be clearly understood.

It's PLAYTIME
A RAG DOLL

1 Start with the head, drawing an ellipse, but leaving a bit unfinished.

2 Next, draw the dress, as well as the arms and legs of the doll, which look like little pillows. Draw in the fringe with fairly wide locks of hair.

3 The hair is looking a bit like neatly arranged string.

4 A bit of hair styling, and she's ready for a cuddle!

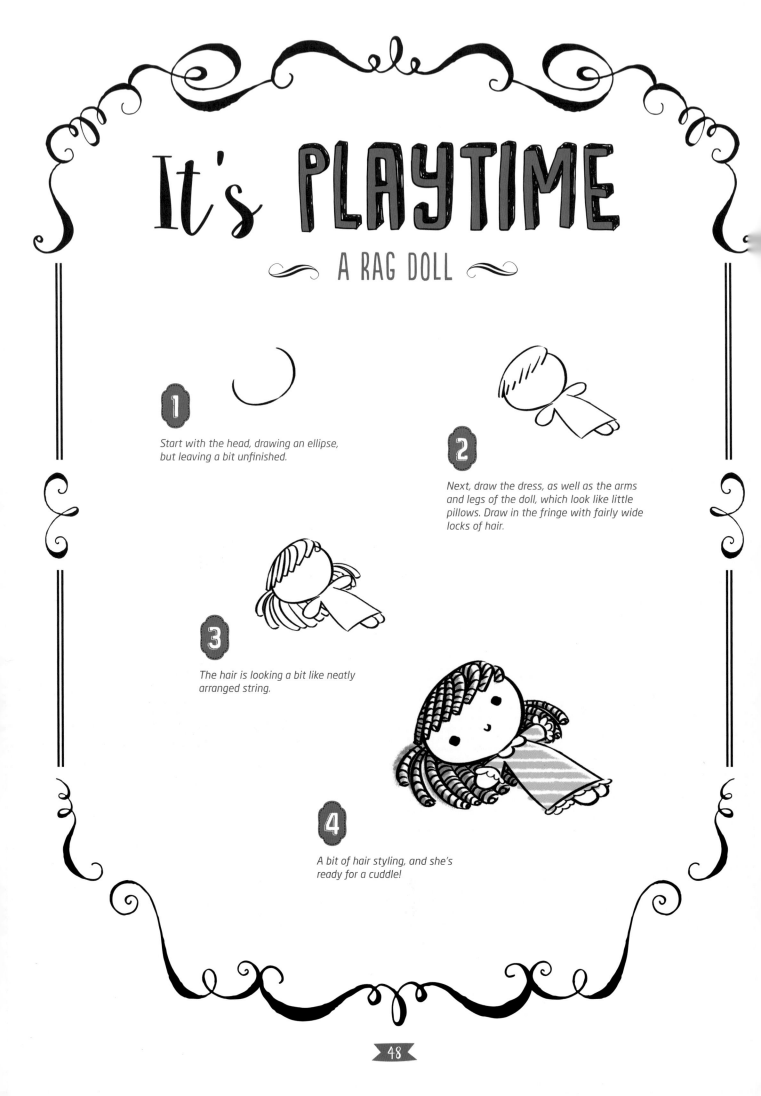

Before drawing in the fur, lightly trace the outline—so you can rub it out later on.

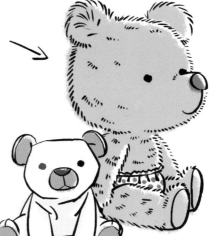

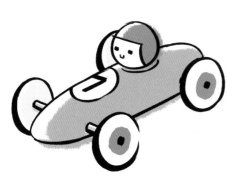

The more you cheat with perspective, the simpler your drawing will look . . . but still really easy to identify!

PRACTICE SPACE

for sketching

How to Draw an Object. COPYRIGHT © 2017 BY MANGO,
AN IMPRINT OF FLEURUS ÉDITIONS.
ALL RIGHTS RESERVED. PRINTED IN CHINA. FOR INFORMATION, ADDRESS
ST. MARTIN'S PRESS, 175 FIFTH AVENUE, NEW YORK, N.Y. 10010.

WWW.STMARTINS.COM

DESIGNED BY CAROLINE SOULÈRES
TRANSLATION BY PAUL CARSLAKE

LIBRARY OF CONGRESS CATALOGING-IN-PUBLICATION DATA

NAMES: MOUTON, SOIZIC, AUTHOR.
TITLE: HOW TO DRAW AN OBJECT : THE FOOLPROOF METHOD / SOIZIC MOUTON.
OTHER TITLES: DESSINE-MOI UN OBJET. ENGLISH
DESCRIPTION: FIRST U.S. EDITION. | NEW YORK : ST. MARTIN'S GRIFFIN, 2018.
IDENTIFIERS: LCCN 2017054903 | ISBN 9781250170088 (TRADE PAPERBACK) |
ISBN 9781250170095 (EBOOK)
SUBJECTS: LCSH: DRAWING—TECHNIQUE.
CLASSIFICATION: LCC NC730 .M6813 2018 | DDC 741.2—DC23
LC RECORD AVAILABLE AT HTTPS://LCCN.LOC.GOV/2017054903

ORIGINALLY PUBLISHED UNDER THE TITLE *Dessine-moi un objet*
IN FRANCE BY MANGO, AN IMPRINT OF FLEURUS ÉDITIONS

OUR BOOKS MAY BE PURCHASED IN BULK FOR PROMOTIONAL, EDUCATIONAL, OR BUSINESS USE.
PLEASE CONTACT YOUR LOCAL BOOKSELLER OR THE MACMILLAN CORPORATE AND PREMIUM
SALES DEPARTMENT AT 1-800-221-7945, EXTENSION 5442, OR BY EMAIL AT
MACMILLANSPECIALMARKETS@MACMILLAN.COM.

FIRST U.S. EDITION: JULY 2018

10 9 8 7 6 5 4 3 2 1